Dean -

May you enjoy this
book as much as I am
enjoying our paint....ther!

Gloria
"1993"

REFLECTIONS
of
FLOWERS

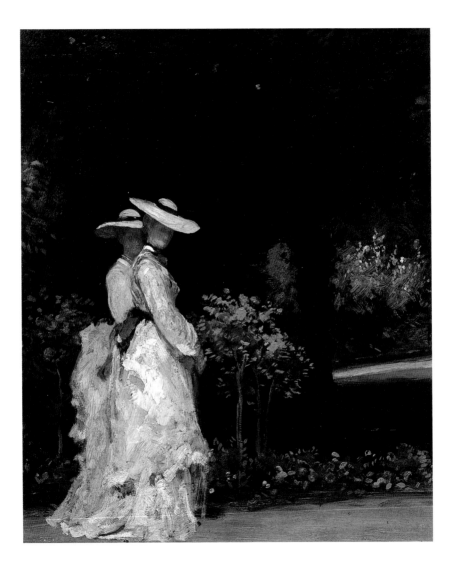

REFLECTIONS

of

Flowers

COMPILED BY JOHN HADFIELD

PICTURES FROM THE TATE GALLERY

A GRAHAM TARRANT BOOK

DAVID & CHARLES
Newton Abbot · London

Cover paper design by courtesy of the Italian
Paper Shop, London

British Library Cataloguing in Publication Data
Reflections of flowers.
 1. Painting. Special subjects: Flowers
 I. Hadfield, John *1907*– II. Tate Gallery
 758.42
 ISBN 0-7153-9893-8

Typeset by ABM Typographics Limited, Hull
and printed in Singapore by C. S. Graphics Pte Ltd.
for David & Charles Publishers plc
Brunel House Newton Abbot Devon

EARTH'S APPAREL

If delight may provoke men's labour, what greater delight is
there than to behold the earth apparelled with plants, as with a
robe of embroidered work, set with Orient pearls and garnished
with great diversity of rare and costly jewels? If this variety and
perfection of colours may affect the eye, it is such in herbs and
flowers that no Apelles, no Xeuxis, ever could by any art express
the like: if odours or if taste may work satisfaction they are both
so sovereign in plants and so comfortable that no confection of
the apothecaries can equal their excellent virtue. But these
delights are in the outward senses; the principal delight is in the
mind, singularly enriched with the knowledge of these visible
things, setting forth to us the invisible wisdom and admirable
workmanship of Almighty God.

JOHN GERARD
Dedication of his Herbal, 1597

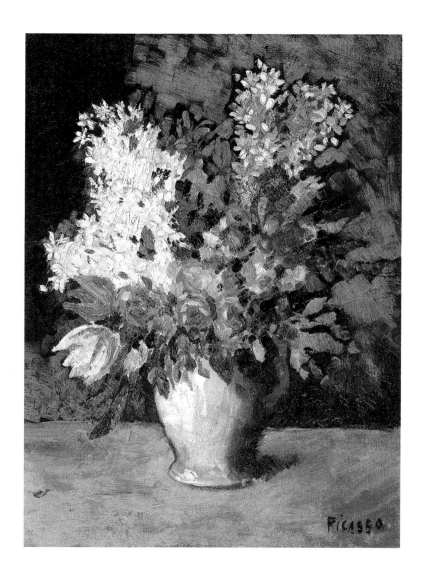

PABLO PICASSO
Flowers, 1901

THE BRIGHT CONSUMMATE FLOWER

Suppose flowers themselves were new! Suppose they had just come into the world, a sweet reward for some new goodness; and that we had not yet seen them quite developed; that they were in the act of growing; had just issued with their green stalks out of the ground, and engaged the attention of the curious. Imagine what we should feel when we saw the first lateral stem bearing off from the main one, or putting forth a leaf. How we should watch the leaf gradually unfolding its little graceful hand; then another, then another; then the main stalk rising and producing more; then one of them giving indications of an astonishing novelty, a bud! then this mysterious, lovely bud gradually unfolding like the leaf, amazing us, enchanting us, almost alarming us with delight, as if we knew not what enchantment were to ensue: till at length, in all its fairy beauty, and odorous voluptuousness, and mysterious elaboration of tender and living sculpture, shone forth
the bright consummate flower!
Yet this phenomenon, to a mind of any thought and lovingness, is what may be said to take place every day; for the commonest objects are only wonders at which habit has made us cease to wonder, and the marvellousness of which we may renew at pleasure, by taking thought.

LEIGH HUNT
'A Flower for Your Window', *London Journal,* 1834

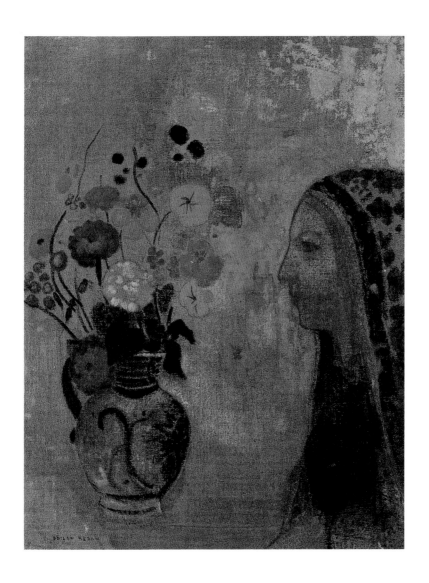

ODILON REDON
Profile of a Woman with a Vase of Flowers, c 1885–1900

Fragrance and Fire

Go, rose, my Chloe's bosom grace.
 How happy should I prove,
Might I supply that envied place
 With never-fading love!
There, Phoenix-like, beneath her eye,
Involved in fragrance, burn and die!

Know, hapless flower, that thou shalt find
 More fragrant roses there;
I see thy withering head reclined
 With envy and despair:
One common fate we both must prove,
You die with envy, I with love.

JOHN GAY
Fables, 1727

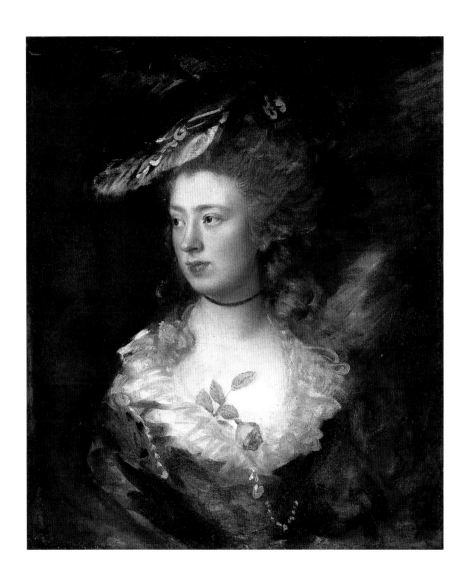

THOMAS GAINSBOROUGH
The Artist's Daughter Mary, 1777

THE GARDEN OF INNOCENCE

I unlock the casket of memory, and draw back the warders of the brain; and there this scene of my infant wanderings still lives unfaded, or with fresher dyes. A new sense comes upon me, as in a dream; a richer perfume, brighter colours start out; my eyes dazzle; my heart heaves with its new load of bliss, and I am a child again. My sensations are all glossy, spruce, voluptuous, and fine: they wear a candied coat, and are in holiday trim. I see the beds of larkspur with purple eyes; tall holy-oaks, red and yellow; the broad sun-flowers, caked in gold, with bees buzzing round them; wildernesses of pinks, and hot-glowing peonies; poppies run to seed; the sugared lily, and faint mignonette, all ranged in order, and as thick as they can grow; the box-tree borders; the gravel walks, the painted alcove . . . I think I see them now with sparkling looks; or have they vanished while I have been writing this description of them? No matter; they will return again when I least think of them. All that I have observed since, of flowers and plants, and grass-plots, and of suburb delights, seems, to me, borrowed from 'that first garden of my innocence' – to be slips and scions stolen from that bed of memory.

WILLIAM HAZLITT
'Why Distant Objects Please', *Table Talk*, 1821

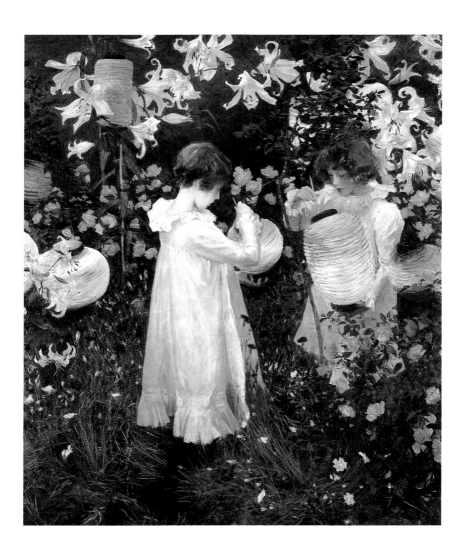

JOHN SINGER SARGENT
Carnation, Lily, Lily, Rose, 1885–86

COME INTO THE GARDEN, MAUD

Come into the garden, Maud,
 For the black bat, night, has flown,
Come into the garden, Maud,
 I am here at the gate alone;
And the woodbine spices are wafted abroad,
 And the musk of the rose is blown.

For a breeze of morning moves,
 And the planet of Love is on high,
Beginning to faint in the light that she loves
 On a bed of daffodil sky,
To faint in the light of the sun she loves,
 To faint in his light, and to die . . .

There has fallen a splendid tear
 From the passion-flower at the gate,
She is coming, my dove, my dear;
 She is coming, my life, my fate;
The red rose cries, 'She is near, she is near;'
 And the white rose weeps, 'She is late;'
The larkspur listens, 'I hear, I hear;'
 And the lily whispers, 'I wait.'

ALFRED, LORD TENNYSON
Maud, and Other Poems, 1855

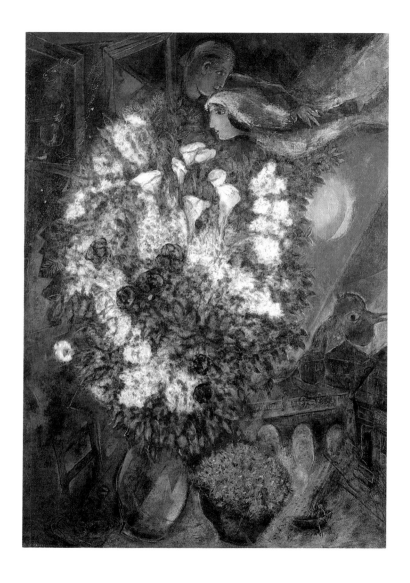

MARC CHAGALL
Bouquet with Flying Lovers, c 1934–47

THE GIRL AT THE GATE

I went across the meadow to the beautiful green lane which leads down to Cwmpelved. At Cwmpelved Green the low garden wall was flaming with nasturtiums, which had clambered over it from the garden and were now swinging their lusty arms and hands about, feeling for some support to take hold of . . . Along the narrow garden border nodded a brilliant row of gigantic sweet williams. Within the cottage sat old Richard Clark and the pretty girl lately Edward Morgan's concubine, now happily his wife. I had thought Edward Morgan had a comfortless, miserable home. I was never more mistaken or surprised. The cottage was exquisitely clean and neat, with a bright blue cheerful wallpaper and almost prettily furnished. A vase of bright fresh flowers stood upon each table, and I could have eaten my dinner off every stone of the floor. The girl said no one ever came near the house to see it. When I began to read to old Clark she sat down quietly to sew. When I had done reading she led me into the garden and showed me her flowers, with which she had taken some pains, for she was very fond of them. No one ever came to see her garden or her flowers, she said. They come on Market Days along a footpath through the field before the house. The girl spoke quietly and there was a shade of gentle melancholy in her voice and manner. I was deeply touched by all that I saw and heard.

THE REVEREND FRANCIS KILVERT
Diary, 22 July 1871

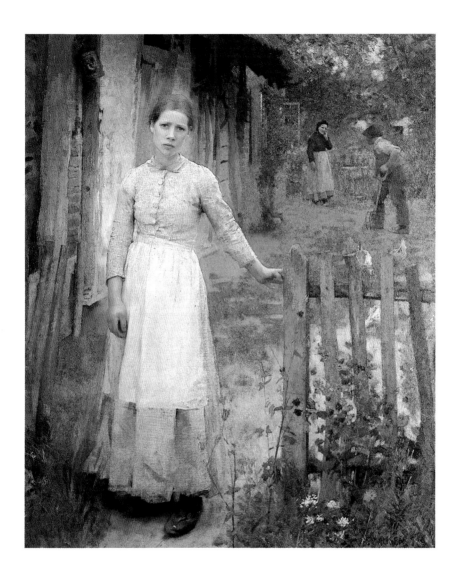

SIR GEORGE CLAUSEN
The Girl at the Gate, 1889

Homage to Hymen, the God of Marriage

Gather ye rose-buds while ye may,
 Old Time is still a-flying:
And this same flower that smiles today,
 Tomorrow will be dying.

The glorious lamp of heaven, the sun
 The higher he's a-getting,
The sooner will his race be run,
 And nearer he's to setting.

That age is best which is the first,
 When youth and blood are warmer;
But being spent, the worse, and worst
 Times still succeed the former.

Then be not coy, but use your time;
 And while ye may, go marry:
For having lost but once your prime,
 You may for ever tarry.

ROBERT HERRICK
Hesperides, 1648

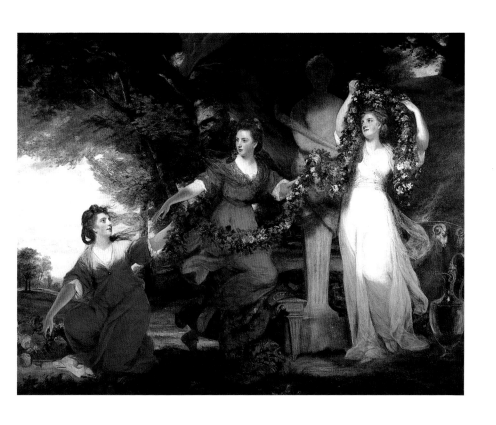

SIR JOSHUA REYNOLDS
Three Ladies Adorning a Term of Hymen, 1773

BUD OF BEAUTY

Sweetest bud of beauty, may
No untimely frost decay
The early glories, which we trace
Blooming in thy matchless face;
But kindly opening, like the rose,
Fresh beauties every day disclose,
Such as by Nature are not shown
In all the blossoms she has blown:
And then, what conquest shall you make,
Who hearts already daily take!
Scorched in the morning with thy beams,
How shall we bear those sad extremes
Which must attend thy threatening eyes
When thou shalt to thy noon arise?

SIR GEORGE ETHEREGE
The New Academy of Compliments, 1671

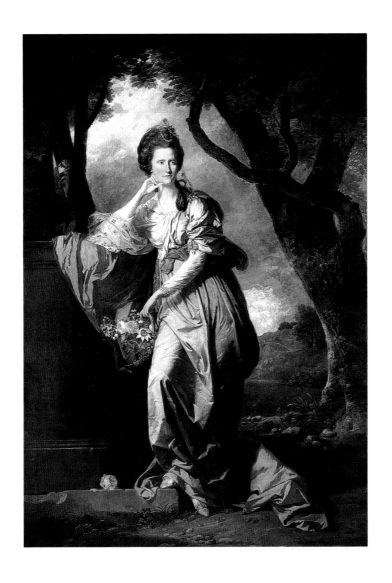

JOHAN ZOFFANY
Mrs Wodhull, c 1770

THE MADONNA LILY

The Madonna lily has a strong claim to be considered both the oldest domesticated flower, and the loveliest. It was in existence 3000 years BC, and is represented on Cretan vases and other objects of the middle Minoan period, between 1750 and 1600 BC; it was known to the Assyrians and to other eastern Mediterranean civilizations, and was probably carried westward by the Phoenicians . . .

It was probably the Romans who brought this lily to England, though we have no record earlier than the tenth century, when it appears in a miniature of Queen Ethelreda, the foundress of Ely Cathedral; unless one counts the reference to it in the writings of the Venerable Bede (637–735). He made the lily the emblem of the Resurrection of the Virgin, the pure white petals signifying her spotless body and the golden anthers her soul glowing with heavenly light. The association of this flower with the Virgin Mary dates from the second century, the tradition being, that when her tomb was visited three days after her burial, it was found empty save for roses and lilies. The lily occurs as her emblem in pictures of the Annunciation from Simone Martini (1284–1344) to Burne-Jones. Strangely enough, the name Madonna lily dates only from the late nineteenth century; before that, it was simply the White Lily, till the introduction of other white lily species made some distinction necessary.

ALICE M. COATS
Flowers and their Histories, 1956

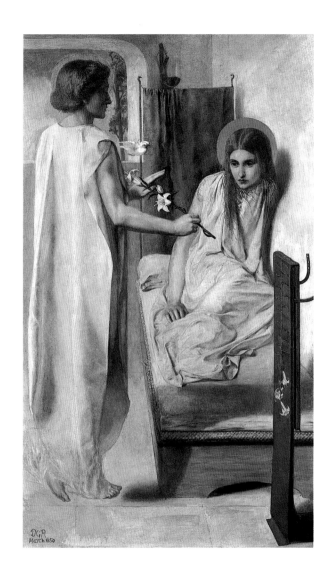

DANTE GABRIEL ROSSETTI
Ecce Ancilla Domini! (The Annunciation) 1849–50

FLOWER DECORATION

The use of cut flowers standing in water for the internal decoration of the house does not go back further than the middle of the nineteenth century. From time immemorial blossoms have been scattered on the floor, beds and dining-tables for decorations and for their scent. Even in the early eighteen-eighties flowers were not all in water; the butler arranged trails of blossom, red flowers, geraniums, cactus, hibiscus, on the white table cloth. The manners and customs of good society regarded hot-house flowers alone to be sufficiently refined to grace the table.

Orchids were very popular. Indeed they are still very popular, though no cut flower lends itself less to decorative use than the orchid . . . They stood in troughs of green-painted tin round a mirror carrying a glass handle; they were stuck into moss and lightly veiled with maidenhair fern. Joe Chamberlain's dinner parties in Princes Gardens were always arranged like this. In the summer the mantelpieces were turned into glorified window-boxes. Florists' shops sold buttonholes and were the rendezvous of gilded youth. In eighteen-eighty a show table was the vogue.

So we have progressed to the time when common garden flowers, chrysanthemums, daffodils, and sweet peas compose floral quincunxes in ten thousand neo-Tudor homes.

SIR WILLIAM LAWRENCE
from the foreword to *Flower Decoration,* by Constance Spry, 1933

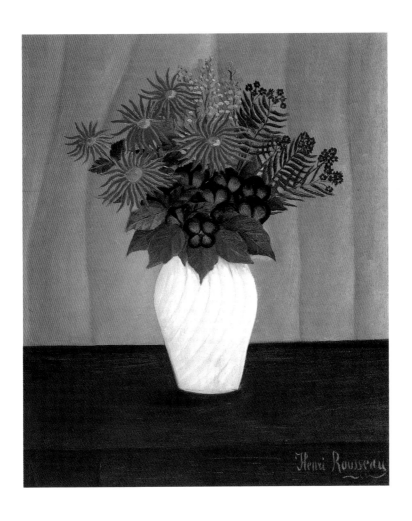

HENRI ROUSSEAU (Le Douanier)
Bouquet of Flowers, c 1909–10

The Wild Rose

Very old are the woods;
 And the buds that break
Out of the brier's boughs,
 When March winds wake,
So old with their beauty are –
 Oh, no man knows
Through what wild centuries
 Roves back the rose.

WALTER DE LA MARE
'All That's Past', *The Listeners,* 1914

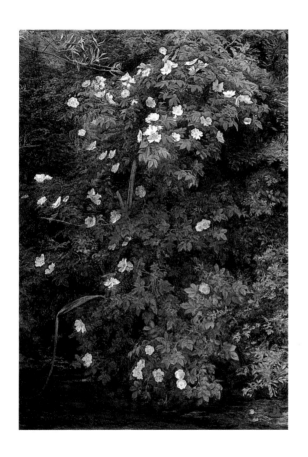

SIR JOHN EVERETT MILLAIS
Ophelia (detail), 1852

THE PRIMROSE

First came the primrose,
On the bank high,
Like a maiden looking forth
From the window of a tower
When the battle rolls below,
So look'd she,
And saw the storms go by.

SYDNEY DOBELL
Complete Poems, 1875

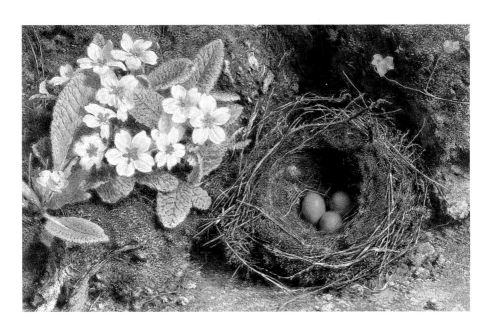

WILLIAM HENRY HUNT (1790–1864)
Primroses and Bird's Nest

The Iris

The word Iris is from the Greek, meaning a rainbow. It is a flower whose history extends far back in time. It is not improbable that 'the lilies of the fields', which we are bidden to consider in the Bible, were in fact not lilies at all, but irises. The iris has not only been known and loved for its beauty for at least two thousand years; it has become a symbol, a resplendent emblem to which all the arts have paid their tribute.

H. E. BATES
A Fountain of Flowers, 1974

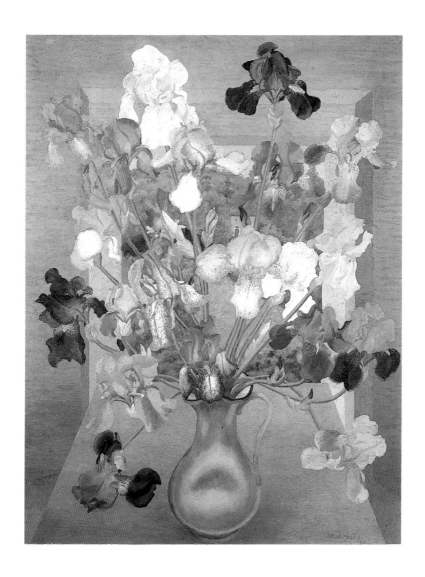

SIR CEDRIC MORRIS, BT
Iris Seedlings, 1943

TULIPOMANIA

The tulip was late in reaching France, where the religious wars had turned men's thoughts away from the gentle pursuit of gardening, and there is no record of a bulb flowering there until 1608. But soon after this, no woman of fashion would be seen in the spring without a bunch of rare blooms tucked into her low-cut dress, and within a few years bulbs were changing hands for fantastic sums . . . The craze spread northwards through Flanders (where Rubens was busy painting his second wife, Helena Fourment, in her new tulip garden) to Holland, which was to be the stage for the most astonishing drama in the whole history of horticulture – the *Tulpenwindhandel,* or Tulipomania.

Soon everyone who had a few square yards of back garden was growing bulbs. The outlay was small – a few breeder tulips; the potential prizes were enormous. Hand in hand with tulip growing went speculation, which, says Beckmann, 'was followed not only by mercantile people, but also by the first noblemen, citizens of every description, mechanics, seamen, farmers, turf-diggers, chimney-sweeps, footmen, maid-servants, old clothes-women, etc. At first everyone won and no one lost.' Then, as the gamble grew wilder, houses and estates were mortgaged; workmen sold the very tools by which they had earned their livelihood; and some of the poorest people 'gained in a few months houses, coaches and horses, and figured away like the first characters in the land'. One speculator is said to have made five thousand pounds sterling in four months; and in a single town, deals to the amount of ten million pounds were made during the three years the mania lasted.

WILFRID BLUNT
Tulipomania, 1950

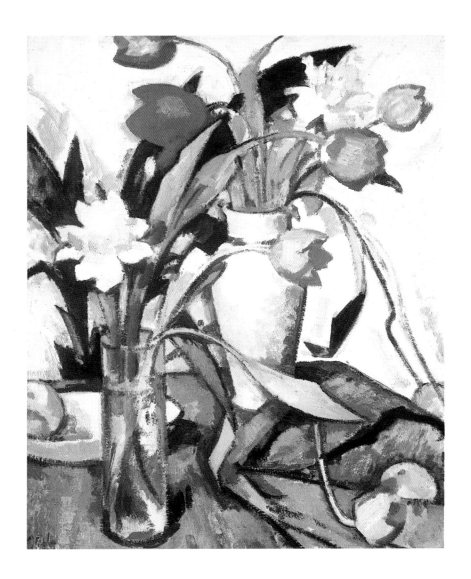

S. J. PEPLOE
Tulips, 1926

WHAT OF THE ASPIDISTRA?

What of the Aspidistra? We are told that its flowers, which appear at ground level, are fertilized by the movements of slugs. Maybe it thereby acquired a sense of inferiority which could only be lived down by a retired life indoors, where at least this shameful act could not be perpetrated. Here, safe from the attentions of revolting garden pests, it can lead a dignified existence, thinking wistfully of its far-away home among the damp rocks of China or Japan, and asking only for an occasional leaf-sponging by the mistress of the house. Nicholson, in his *Dictionary of Gardening,* says that the Aspidistra is hardy. If that is so, should there not be a mass movement for the general release of countless Aspidistras from countless boarding houses, and a great enlightened planting out of them in dells and grottoes? But stay, we have forgotten the slugs!

JOHN NASH
'Cottage Window Plants', from *The Saturday Book,* 1957
[The plant at the bottom of the painting is *Aspidistra elatior.*]

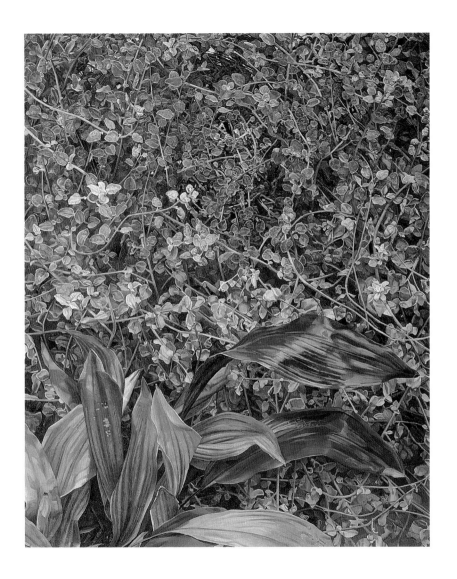

LUCIAN FREUD
Two Plants, 1979–80

In a Village Garden

I know nothing so pleasant as to sit there on a summer afternoon, with the western sun flickering through the great elder-tree, and lighting up our gay parterres, where flowers and flowering shrubs are set as thick as grass in a field, a wilderness of blossoms, interwoven, intertwined, wreathy, garlandy, profuse beyond all profusion, where we may guess that there is such a thing as mould, but never see it. I know nothing so pleasant as to sit in the shade of that dark bower, with the eye resting on that bright piece of colour, lighted so gloriously by the evening sun, now catching a glimpse of the little birds as they fly rapidly in and out of their nests – for there are always two or three birds' nests in the thick tapestry of cherry-trees, honeysuckle, and china-roses, which covers our walls – now tracing the gay gambols of the common butterflies, as they sport around the dahlias; now watching that rarer moth, which the country people, fertile in pretty names, call the bee-bird;

Nothing so pleasant as to sit amid that mixture of the flower and leaf watching the bee-bird! Nothing so pretty to look at as my garden! It is quite a picture; only unluckily it resembles a picture in more qualities than one, – it is fit for nothing but to look at.

MARY RUSSELL MITFORD
Our Village, 1832

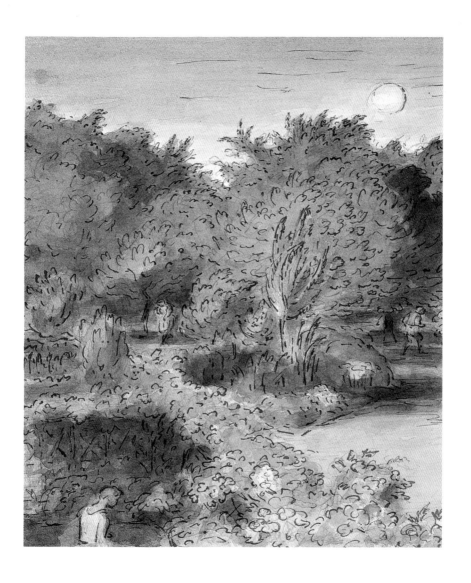

EDWARD ARDIZZONE
View from the Window of my Studio in Kent (detail), 1967

THE SECRET GARDEN

It was the sweetest, most mysterious-looking place anyone could imagine. The high walls which shut it in were covered with the leafless stems of climbing roses, which were so thick that they were matted together . . . There were numbers of standard roses which had so spread their branches that they were like little trees. There were other trees in the garden, and one of the things which made the place look strangest and loveliest was that climbing roses had run all over them and swung down long tendrils which made light swaying curtains, and here and there they had caught at each other or at a far-reaching branch and had crept from one tree to another and made lovely bridges of themselves . . . Their thin grey or brown branches and sprays looked like a sort of hazy mantle spreading over everything, walls and trees, and even brown grass, where they had fallen from their fastenings and run along the ground. It was this hazy tangle from tree to tree which made it look so mysterious.

FRANCES HODGSON BURNETT
The Secret Garden, 1911

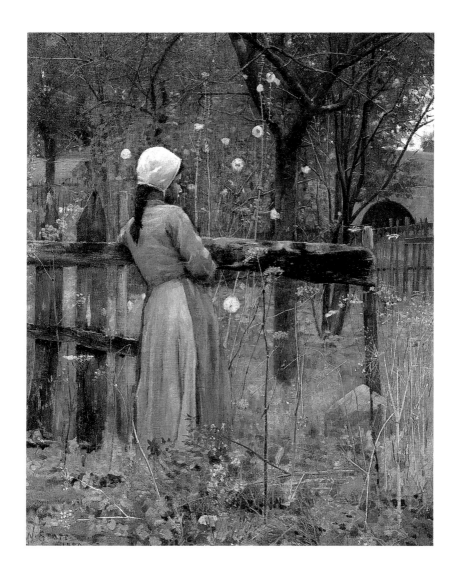

WILLIAM STOTT
Girl in a Meadow, 1880

Advice to the Fair Sex

If I could influence the fair sex, there is one thing to which I would draw their attention; and that is Horticulture; and, connected with this, I would recommend them, as far as convenient, to become Florists, as this delightful and healthy employment – which has been long enough in the rude hands of men – would entice them into the open air, stimulate them to exertion and draw them away from their sedentary modes of life, mewed up in closed rooms, where they are confined like nuns. This would contribute greatly to their amusement, and exhilarate their spirits.

Every sensible man should encourage the fair sex to follow this pursuit. What would this world be without their help, to alleviate its burdens? It would appear a barren waste. It would no longer be a wide-spread garden of Eden, nor an earthly paradise within the reach of our enjoyments. May the fruits and flowers of it, reared and presented by their fair hands, ever operate as a charm in ensuring the attentions and unabating regard of all men!

THOMAS BEWICK
A Memoir written by Himself, 1822 (published in 1862)

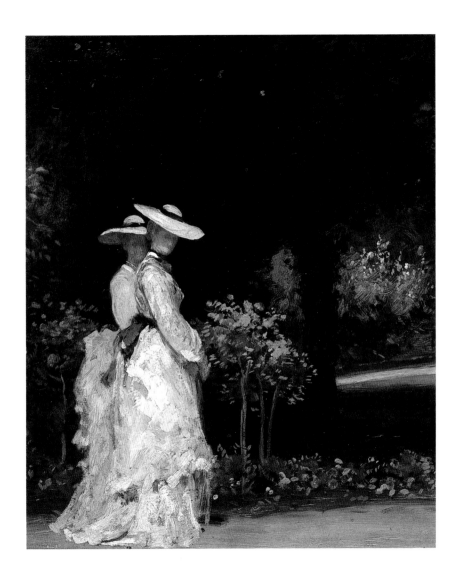

JAMES SANT
Miss Martineau's Garden (detail), 1873

A CONTEMPLATION UPON FLOWERS

Brave flowers, that I could gallant it like you,
 And be as little vain!
You come abroad, and make a harmless show,
 And to your beds of earth again;
You are not proud; you know your birth,
For your embroidered garments are from earth.

You do obey your months and times, but I
 Would have it ever Spring,
My fate would know no Winter, never die,
 Nor think of such a thing;
Oh that I could my bed of earth but view
And smile, and look as cheerfully as you!

Oh, teach me to see Death, and not to fear,
 But rather to take truce.
How often have I seen you at a bier,
 And there look fresh and spruce;
You fragrant flowers, then teach me that my breath,
Like yours, may sweeten and perfume my death.

HENRY KING, BISHOP OF CHICHESTER (1592–1669)
Harleian manuscript in the British Museum (written before 1630)

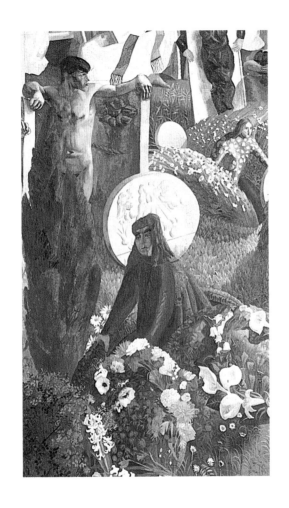

SIR STANLEY SPENCER
The Resurrection, Cookham (detail), 1923–27

GARDENERS

Gardeners are good. Such vices as they have
Are like the warts and bosses in the wood
Of an old oak. They're patient, stubborn folk,
As needs must be whose busyness it is
To tutor wildness, making war on weeds.
With slow sagacious words and knowing glance
They scan the sky, do all that mortals may
To learn civility to pesty birds
Come after new green peas, cosset and prune
Roses, wash with lime the orchard trees,
Make sun-parlours for seedlings.

 Patient, stubborn.
Add cunning next, unless you'd put it first;
For while to dig and delve is all their text
There's cunning in their fingers to persuade
Beauty to bloom and riot to run right,
Mattock and spade, trowel and rake and hoe
Being not tools to learn by learning rules
But extra limbs these husbands of the earth
Had from their birth. Of malice they've no more
Than snaring slugs and wireworms will appease,
Or may with ease be drowned in mugs of mild.
Wherefore I say again, whether or not
It is their occupation makes them so,
Gardeners are good, in grain.

GERALD BULLETT
Poems, 1949

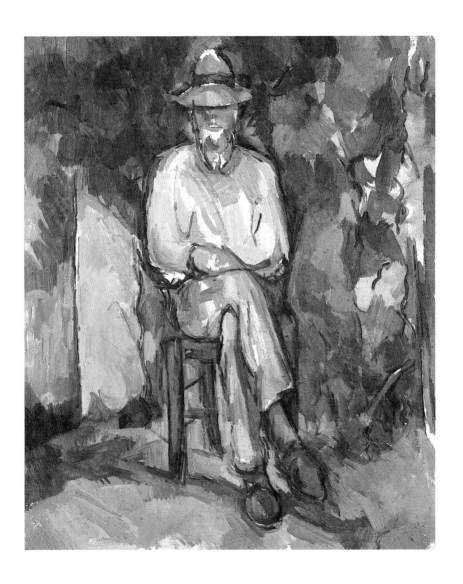

PAUL CÉZANNE
The Gardener, 1906

ACKNOWLEDGEMENTS

The publishers gratefully acknowledge permission to reproduce the following
copyright material:

William Plomer (Ed)
Kilvert's Diaries
reprinted by permission of Mrs Sheila Hooper and Jonathan Cape Limited

Alice M. Coats
Flowers and their Histories
reprinted by permission of A. & C. Black (Publishers) Limited

Sir William Lawrence
his foreword to *Flower Decoration* by Constance Spry
reprinted by permission of J. M. Dent

Walter de la Mare
The Listeners
reprinted by permission of The Literary Trustees
of Walter de la Mare and the Society of Authors
as their representative

H. E. Bates
A Fountain of Flowers
reprinted by permission of the Estate of H. E. Bates

Wilfrid Blunt
Tulipomania
reprinted by permission of Collins Publishers

John Nash
The Saturday Book 1957
reprinted by permission of The Random Century Group Limited

Gerald Bullett
Poems
reprinted by permission of the Estate of Gerald Bullett